Psychedelic Brain Freeze: An Adult Coloring Book

by

Stephen Jorgensen
(artist)

published by
CyberSuccess Publishing
Honolulu, Hawaii

This book is a coloring book for adults. It is more complicated than a child's coloring book with smaller and finer details. You have to concentrate to color in all the small shapes. That makes it an ideal method to clear your mind of many negative thoughts and it helps you relieve stress. Coloring will reduce anxiety, and help you focus and will bring you more mindfulness. It is therapeutic.

This book has a lot of abstract geometrical shapes in the designs. It is up to you how to color them. There are no right colors, or wrong colors. You don't have to think, you don't have to match colors. Just color the shapes how you feel like at the moment. It is a great way to clear your mind and relax.

This coloring book is set-up for weird far-out coloring effects and is great fun. You may easily discover an eye-catching design developing in your coloring. The artist has done other coloring books but he specializes in bigger Hawaiian paintings. All the work here is by the Hawaiian artist Stephen E Jorgensen. He has over 200 other works of beautiful Hawaiian art available on his Etsy website. Most of his work is large canvas wall hangings, some of which are reduced to coloring pages for his Hawaiian Scenes books. See these at hawaiiseascapes.etsy.com.

Feel free to make copies of the pages you are working on so you can try different coloring schemes. If you develop one that you really like, you can order a large poster sized coloring pages from our web site at Etsy. hawaiiseascapes.etsy.com and then make your own poster art. They come in 11" X 17" and 17" X 22" sizes.

Psychedelic Brain Freeze

ISBN-13:
978-1544923925

ISBN-10:
1544923929

copyright © Stephen E Jorgensen
2017

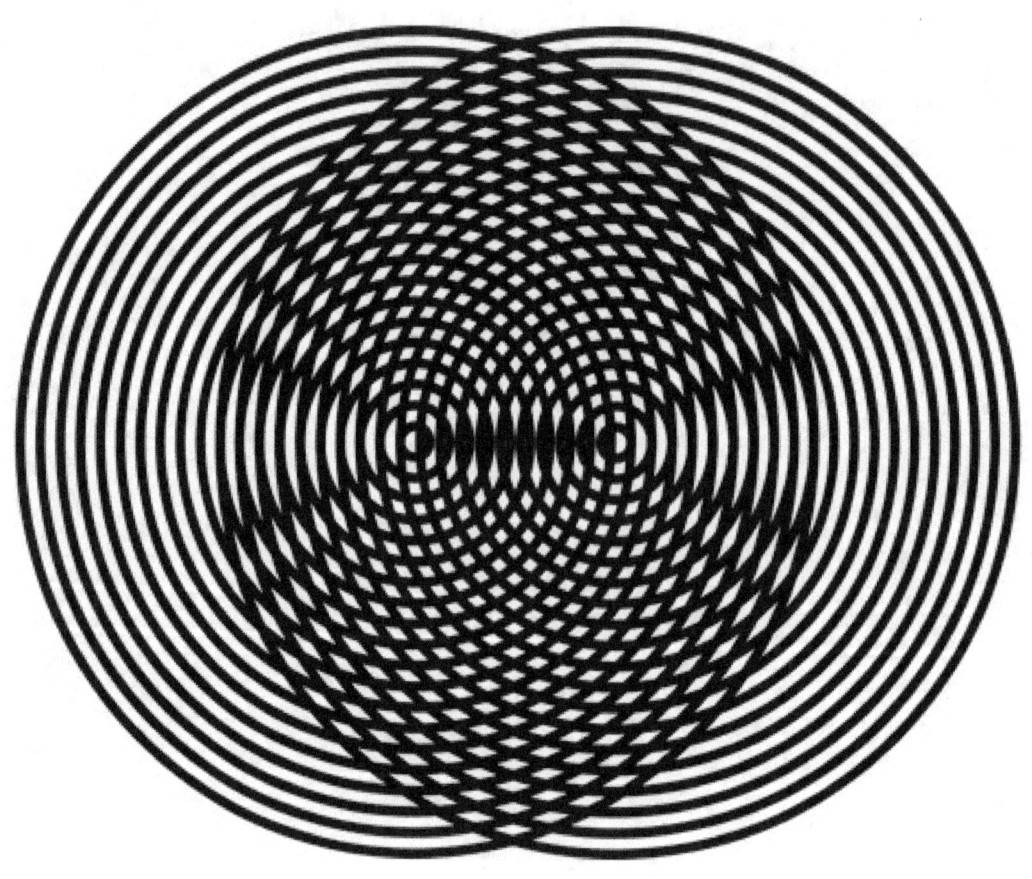

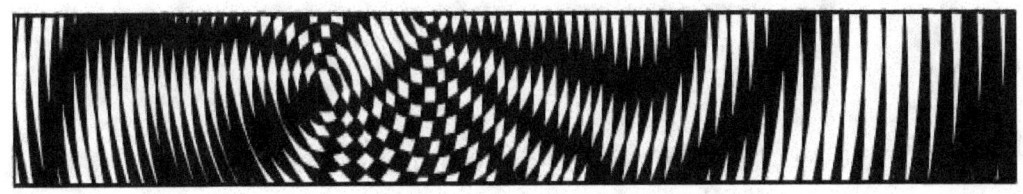

Psychedelic Brain Freeze:
An Adult Coloring Book

The designs here are simple shapes circles, and lines that often overlap and cause optical effects such as moire patterns, often they are a form of Optical Art that were made to dazzle the eyes when just in a black and white form. They look more interesting in color, but to get the effect, the colors should alternating dark and light. You can look look at the full color samples shown on the front and back covers to see a way to color the shapes and what the result could look like. You don't have to use the same colors but the images on the covers give you an idea.

If you do shading of the shapes then many of the colors are just slightly different, so it is best to used a large selection of colored pencils to be able to find an appropriate color, and it helps to "layer" two different colors to get a better match. For instance, coloring a purple over a red will give a darker more scarlet red.

All the coloring pages are one side only, so no bleed-through will mess up a drawing on the opposite side of the page if you do use color marking pens.

Enjoy your coloring. Relax, don't think too much, Freeze your Brain!

This Psychedelic Coloring Therapy
Will relax you. You don't need drugs.

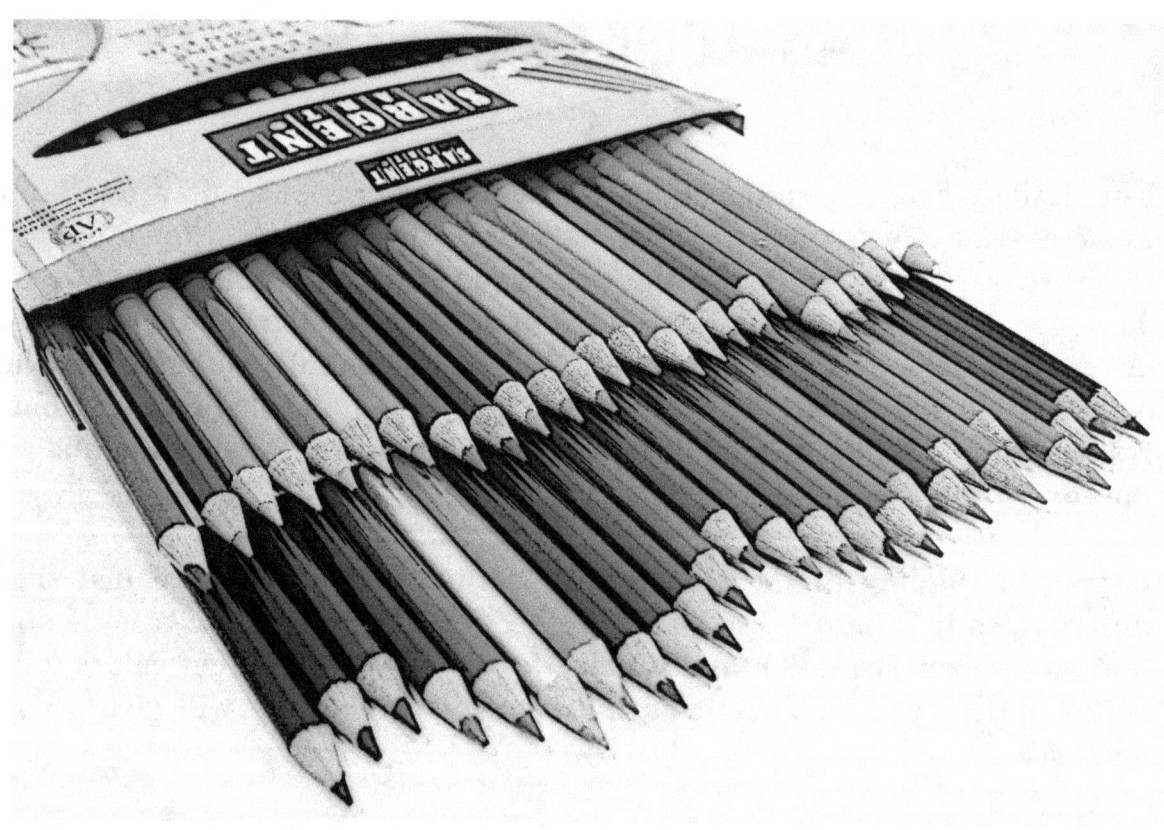

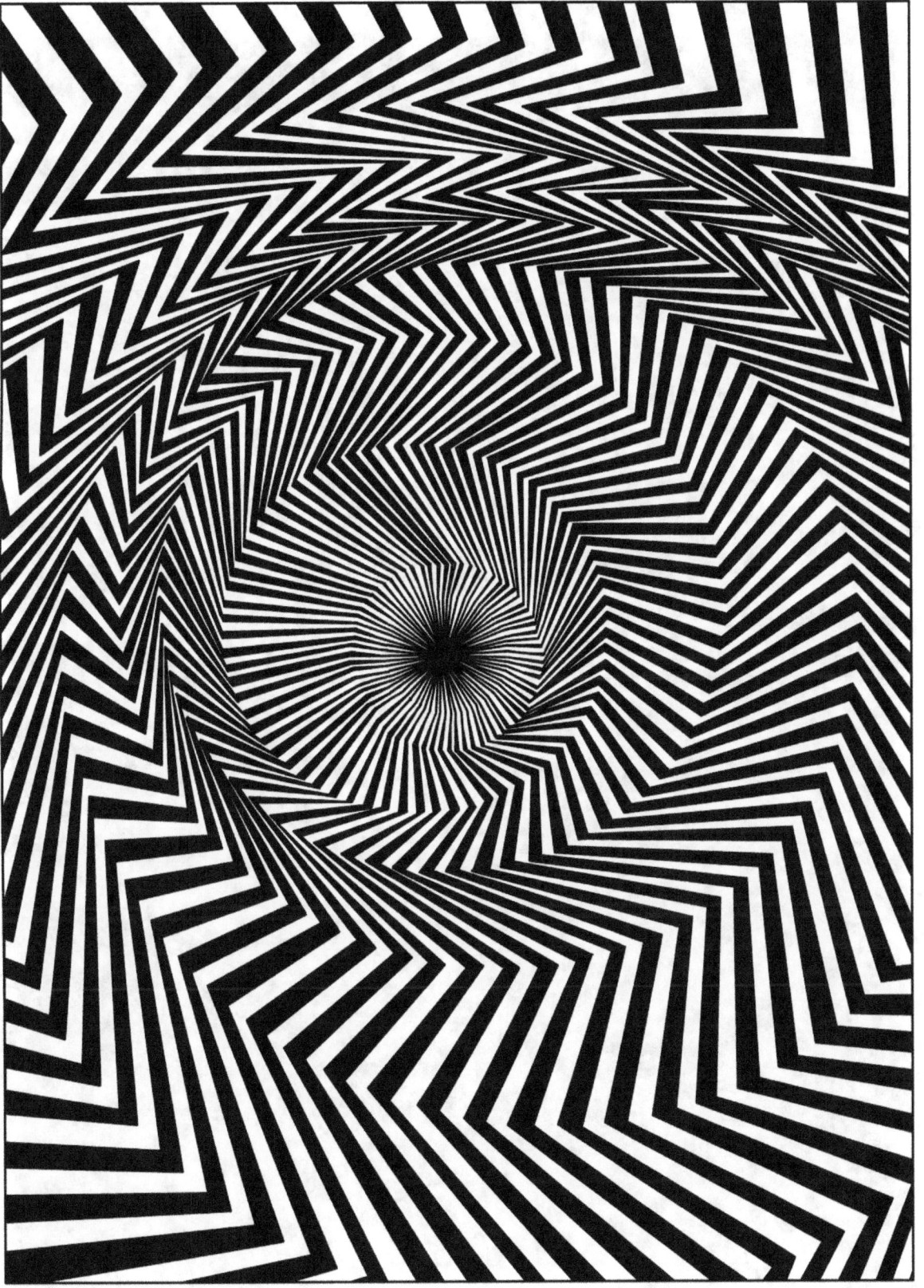

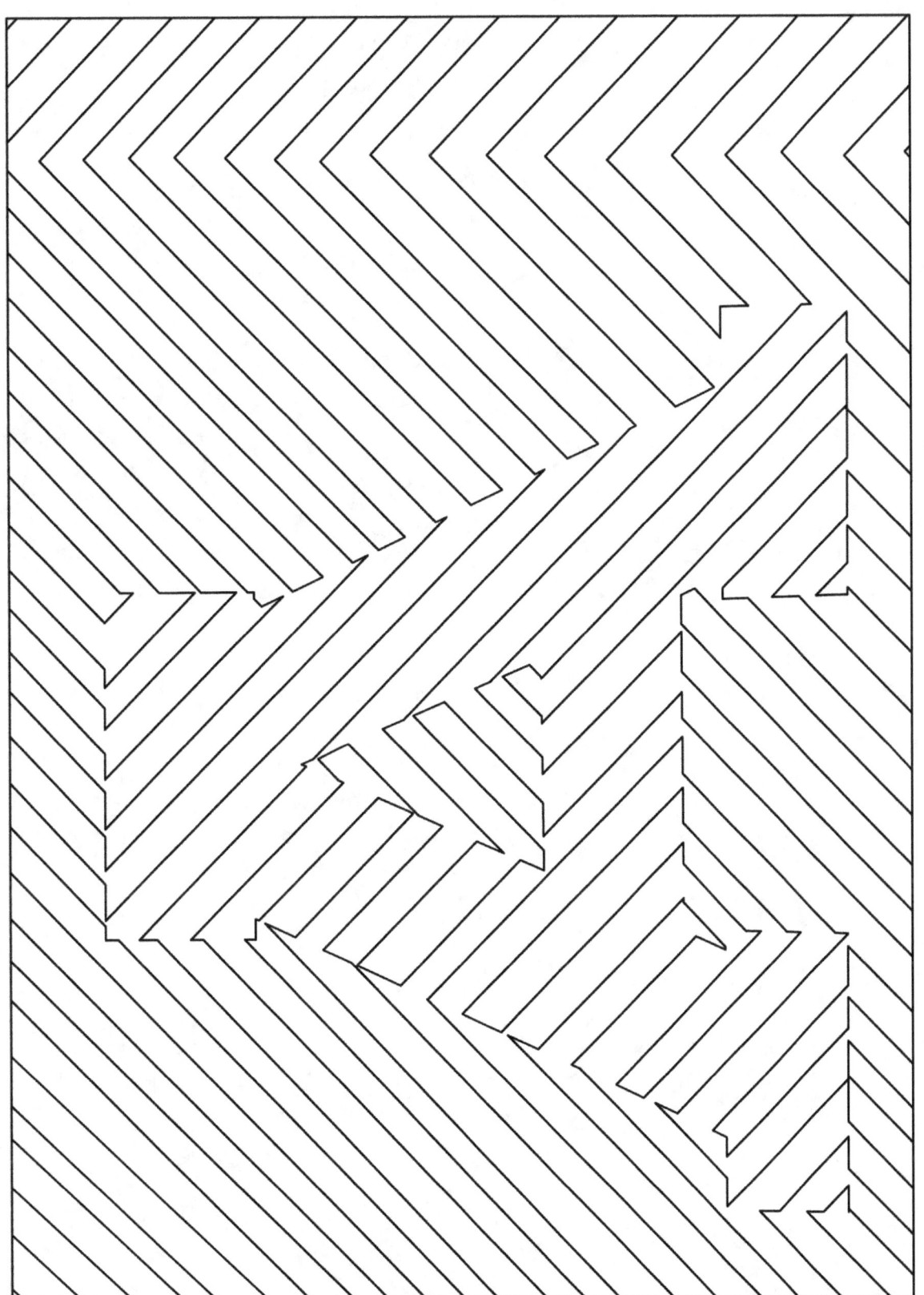

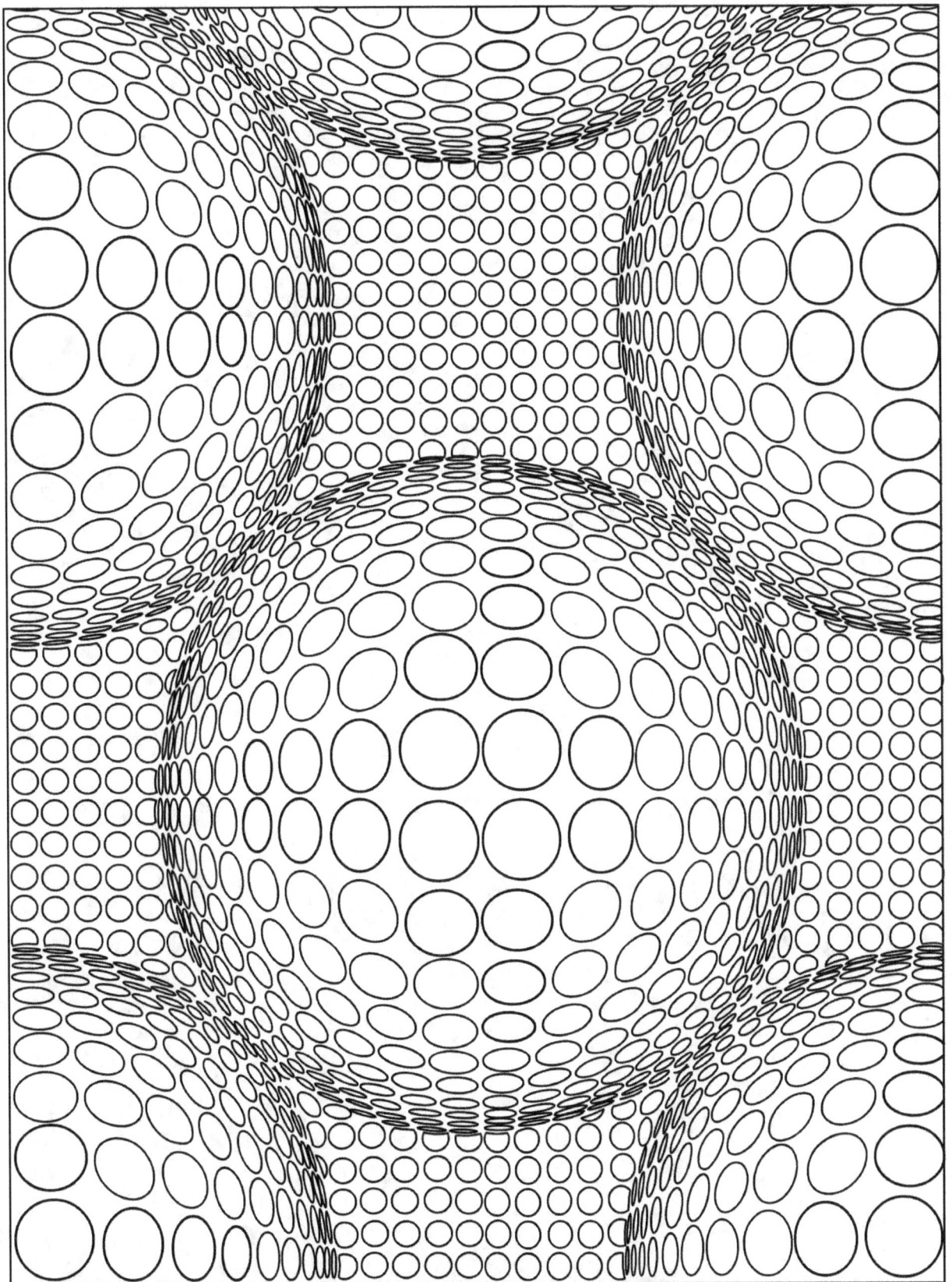

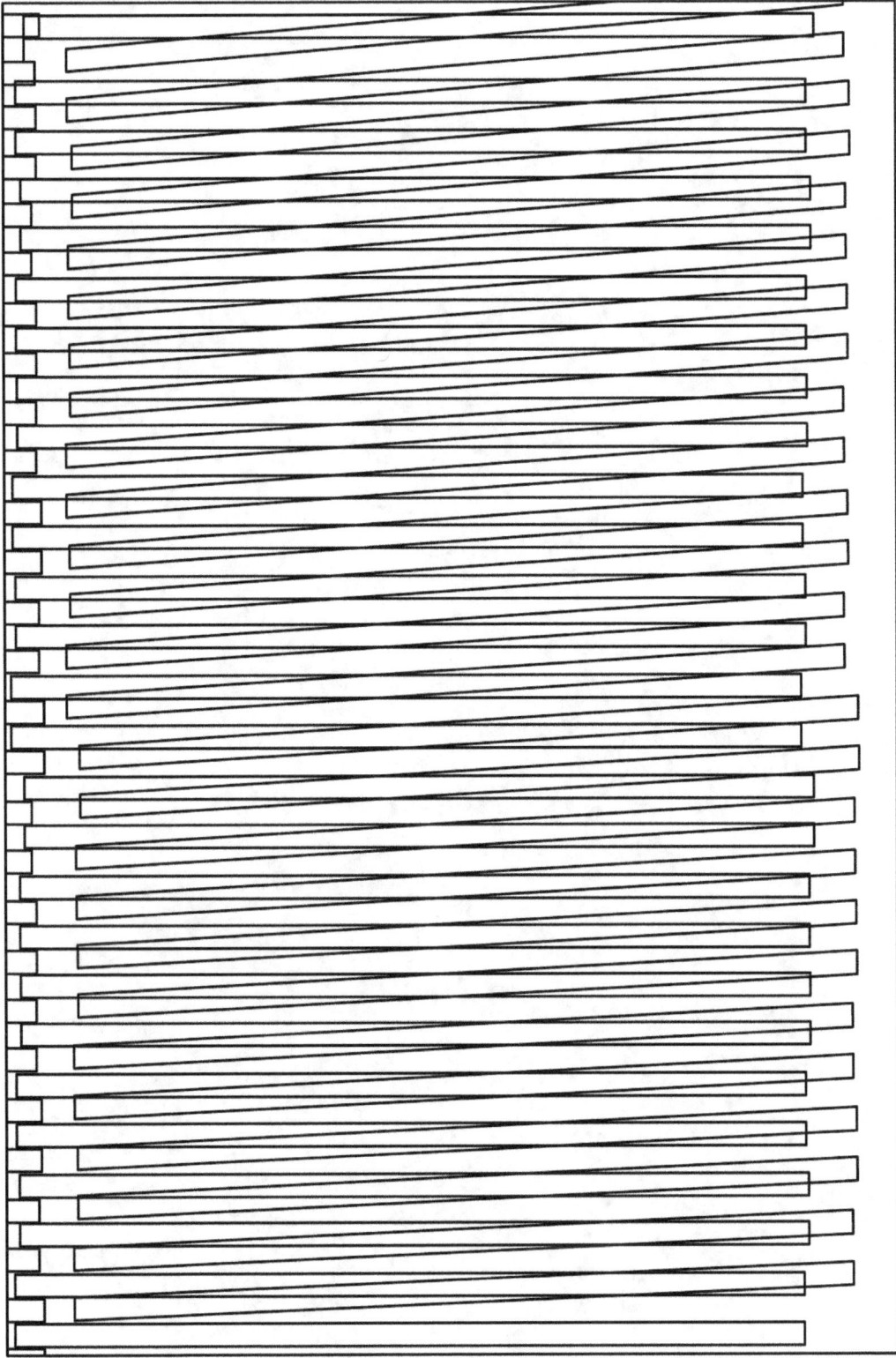

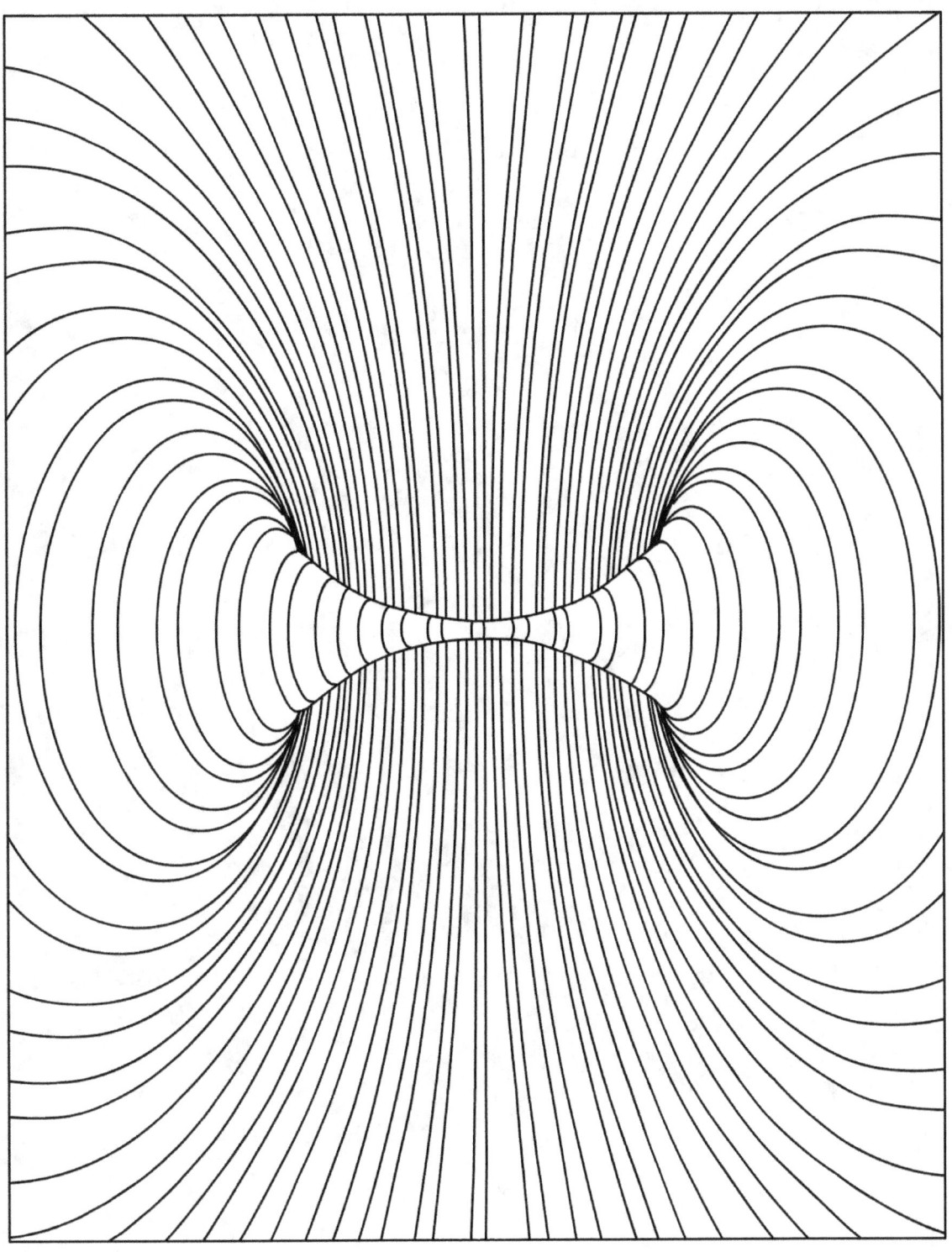

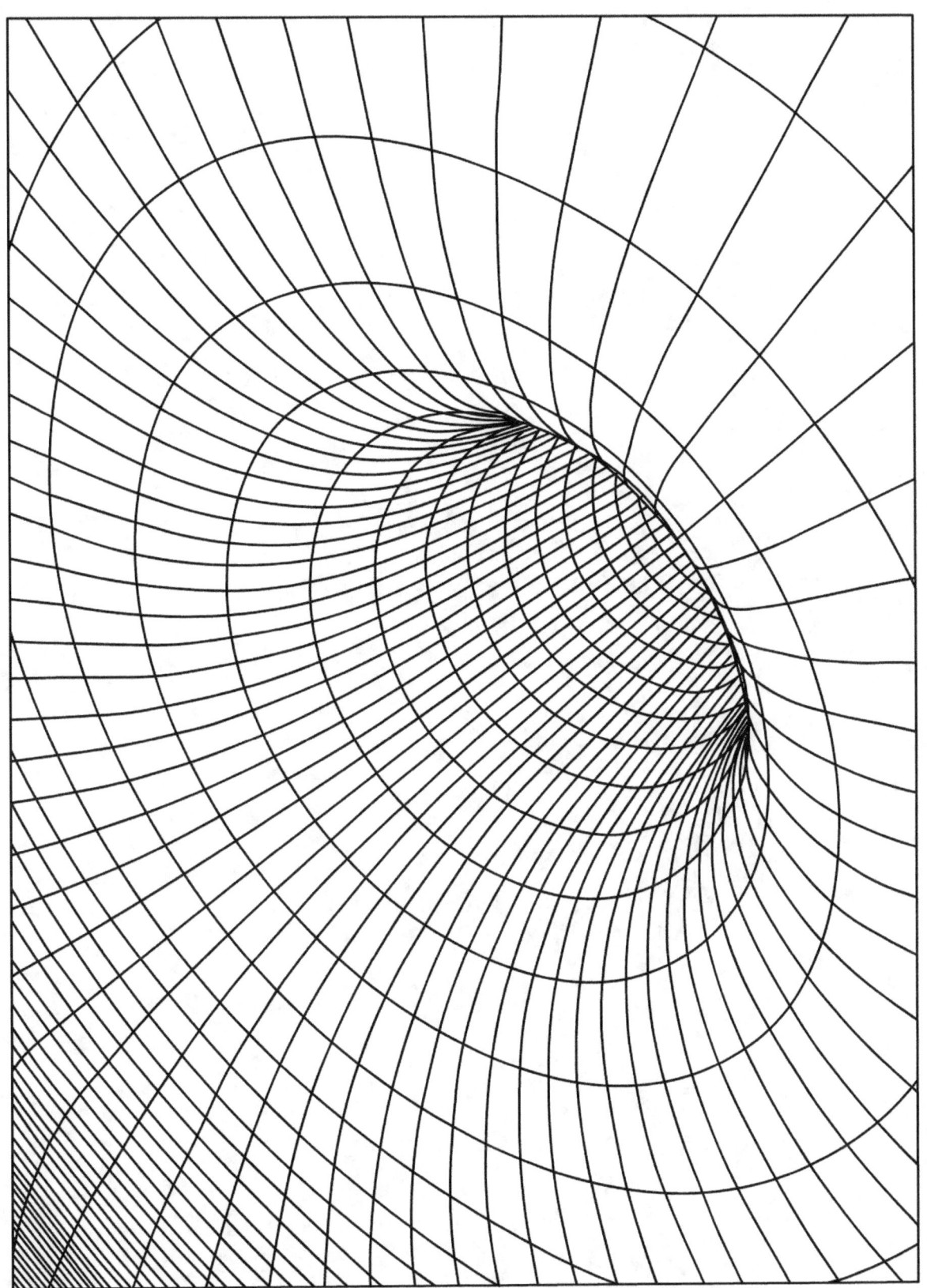

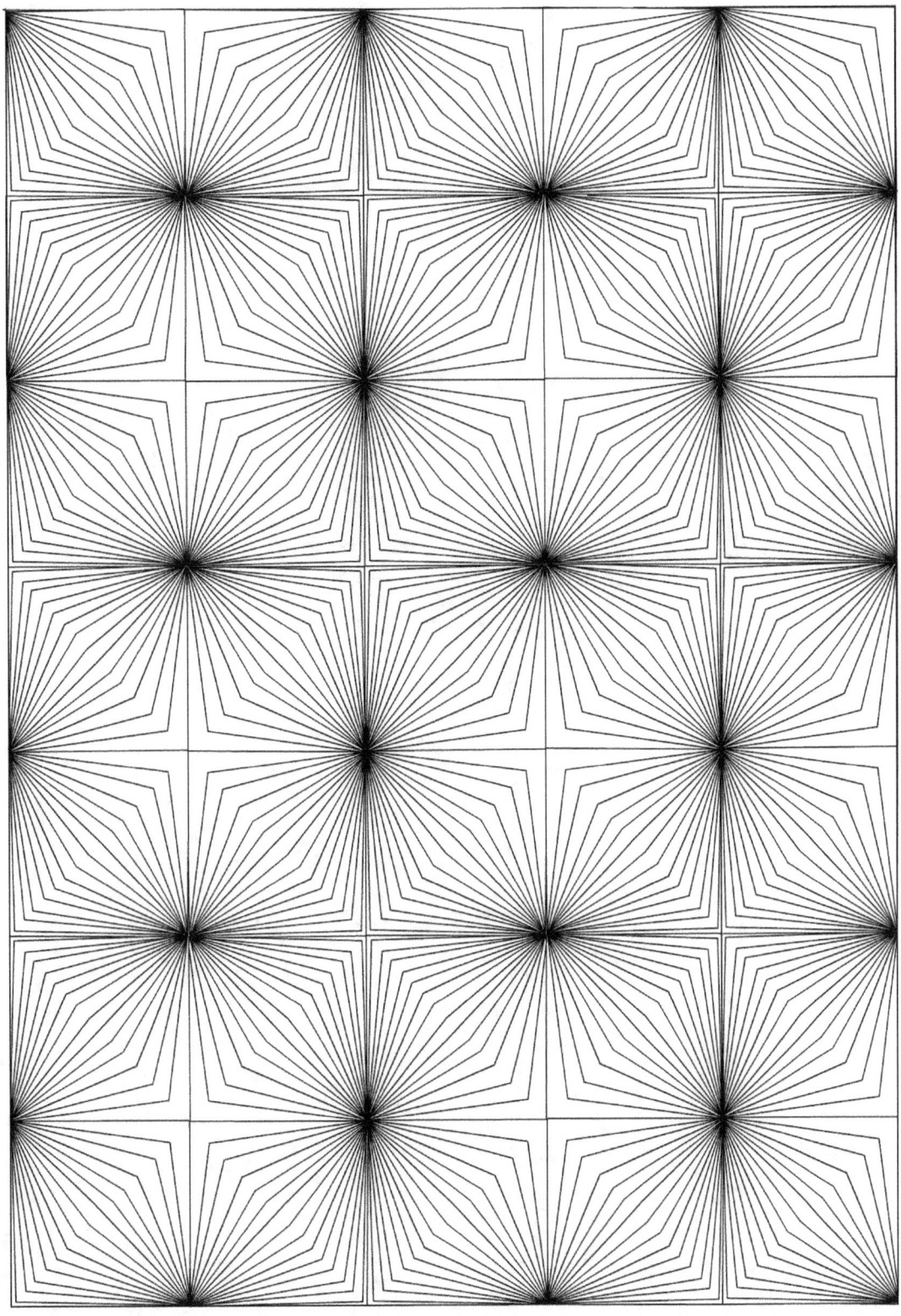

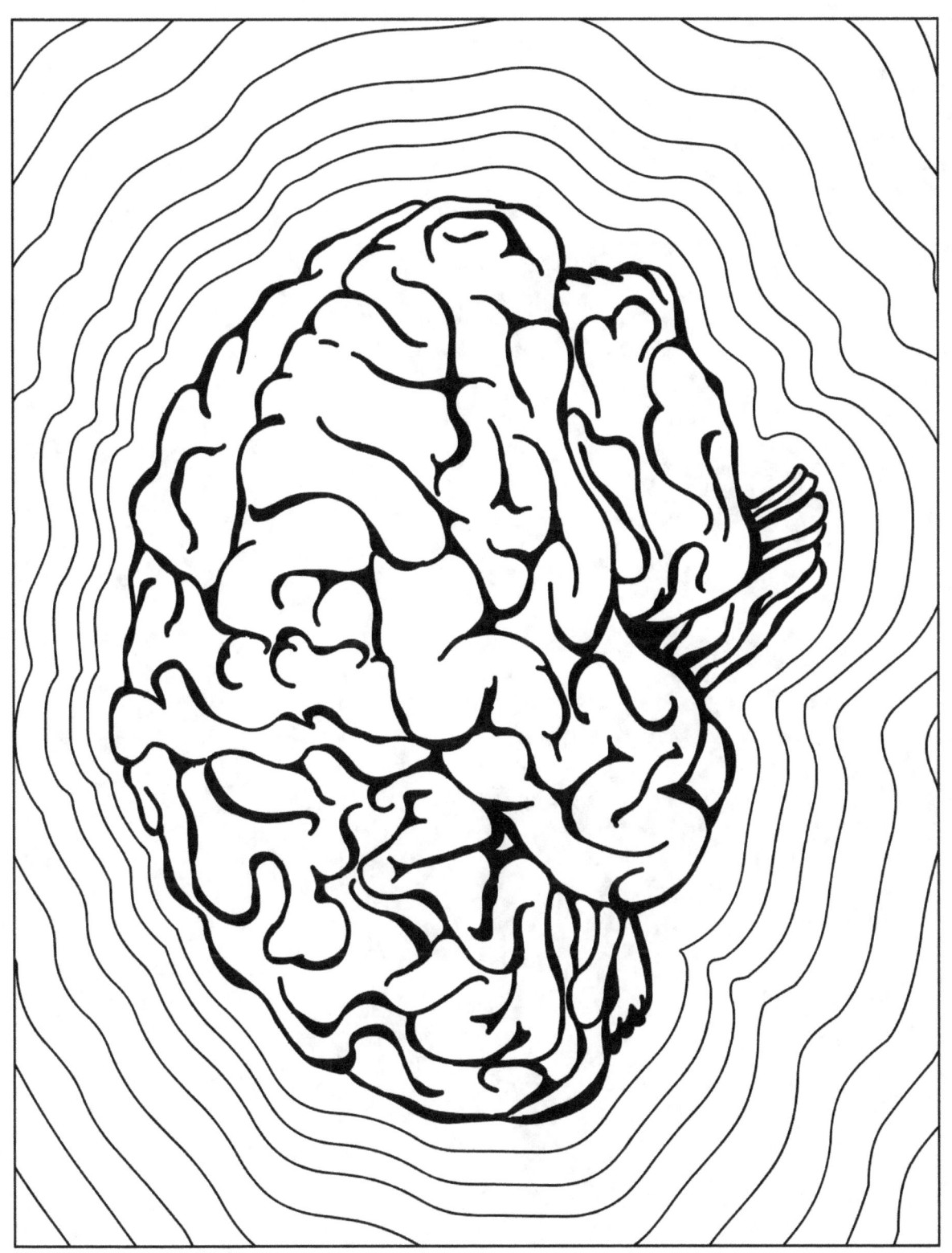

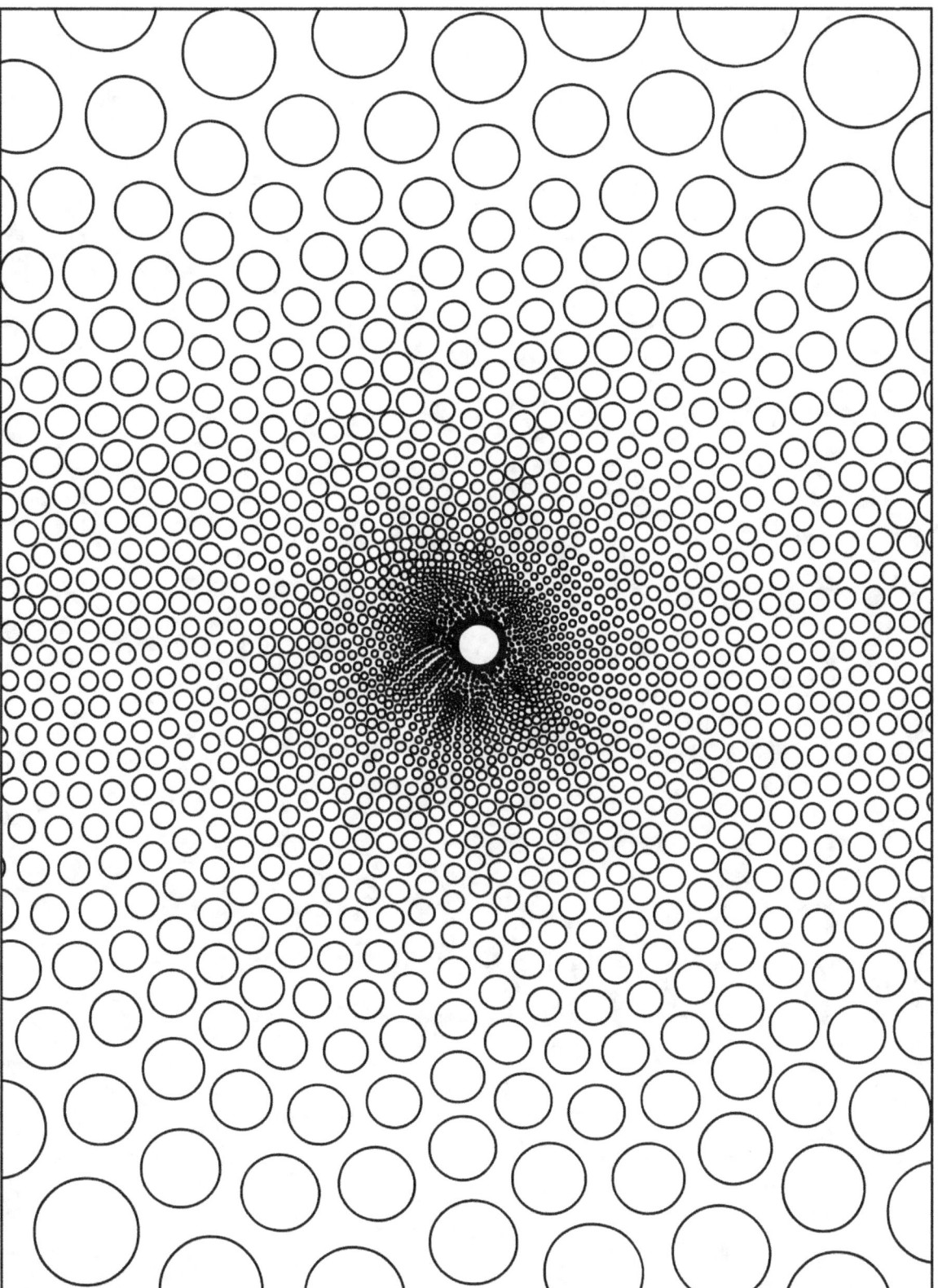

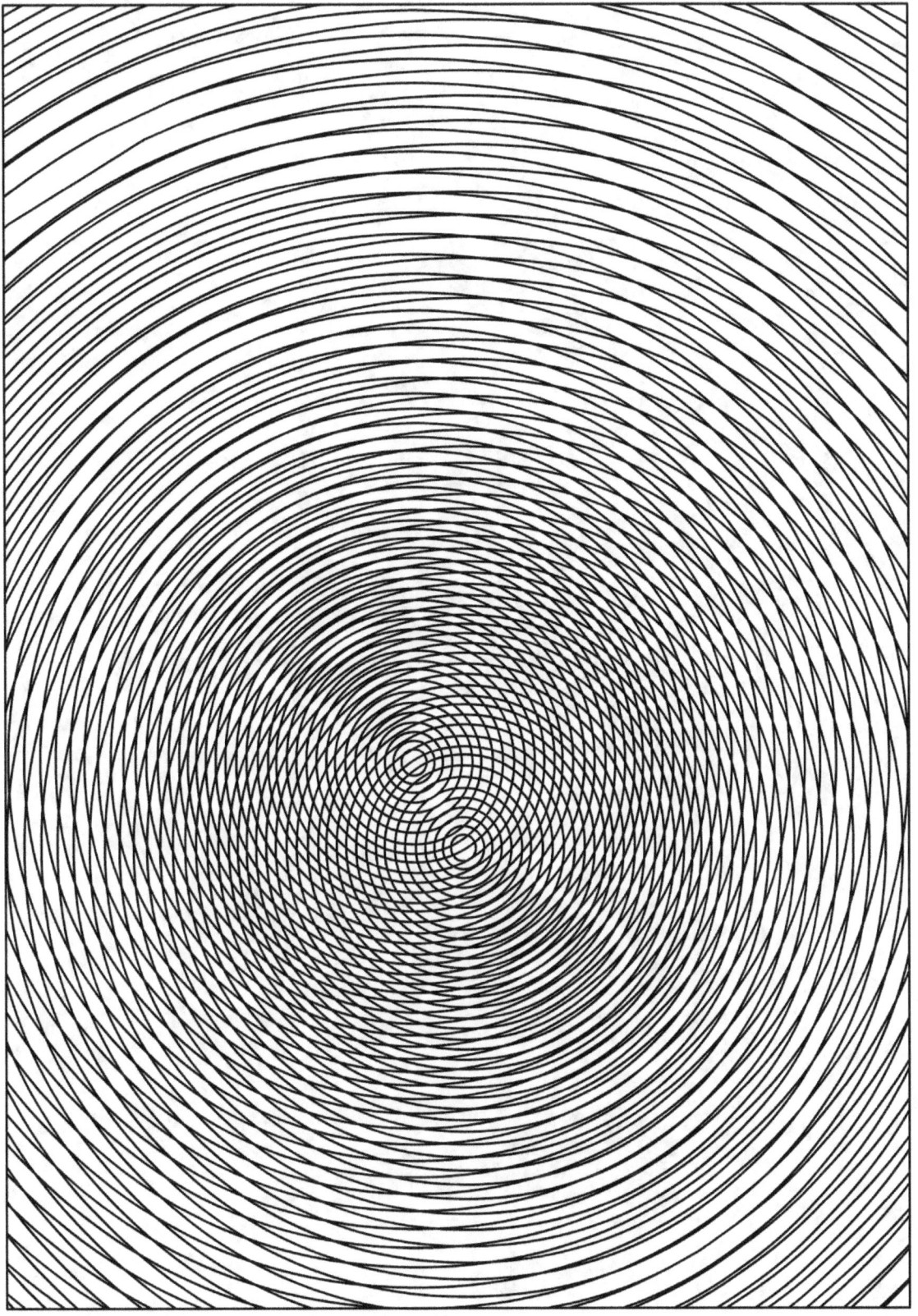

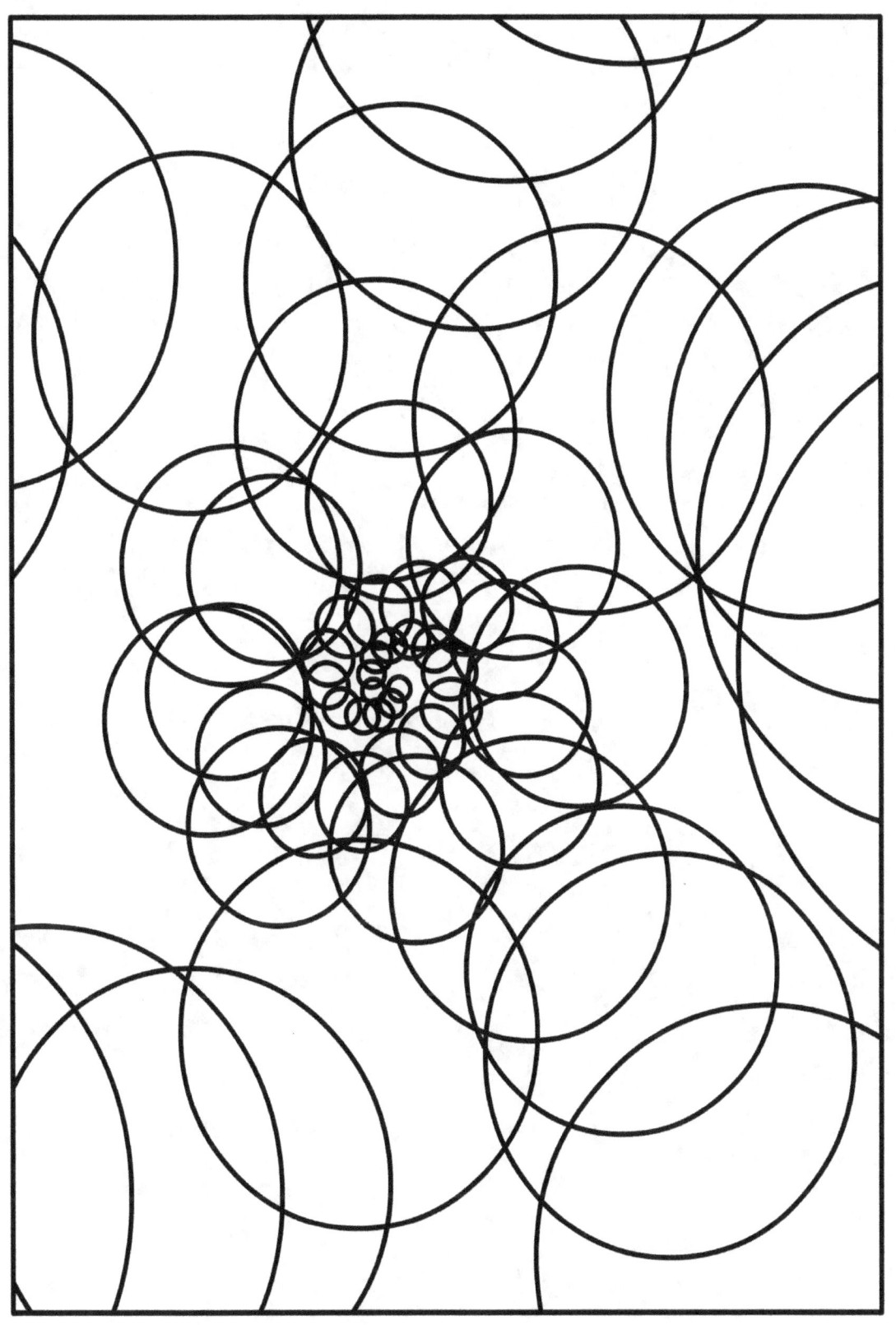

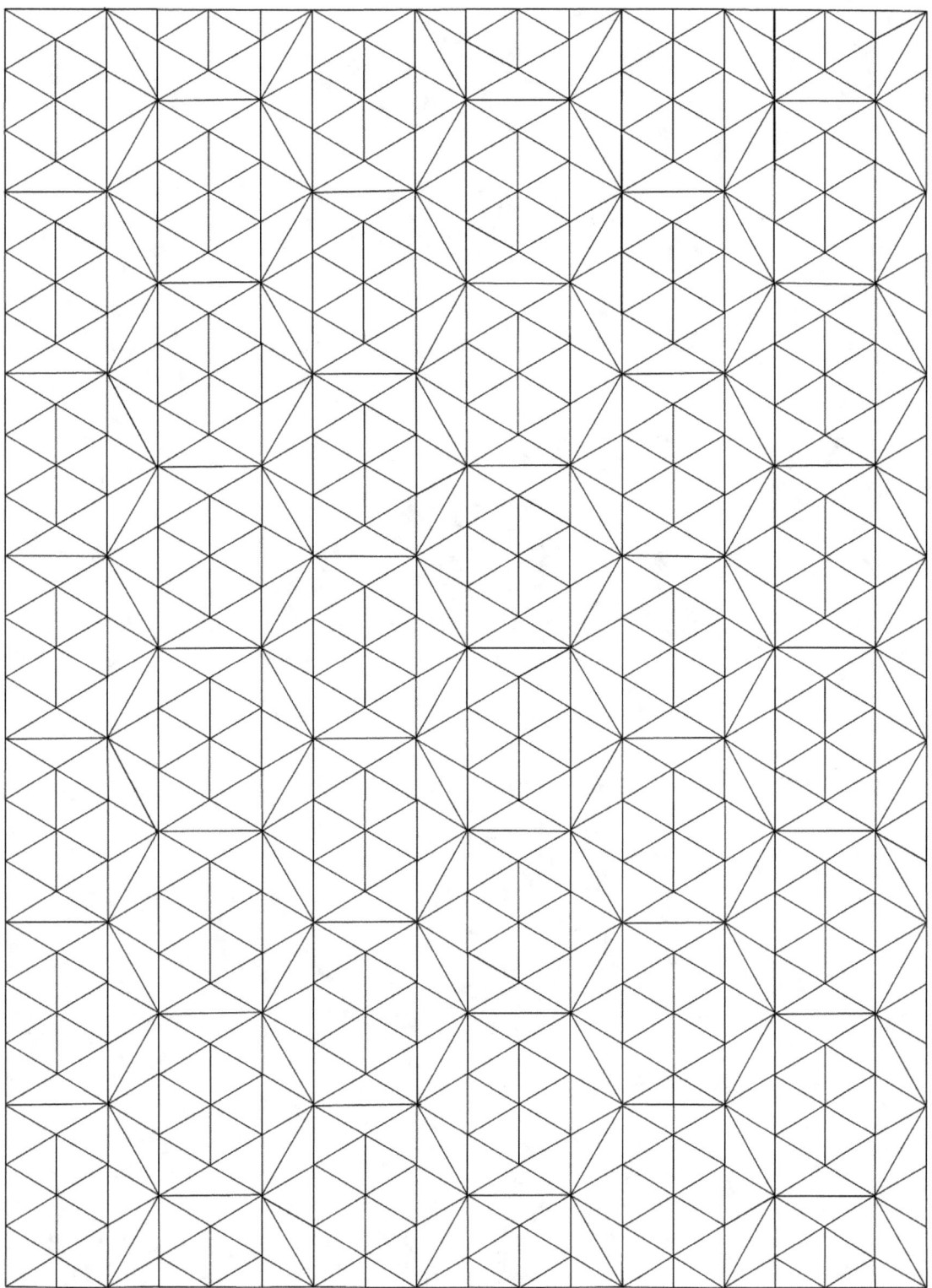

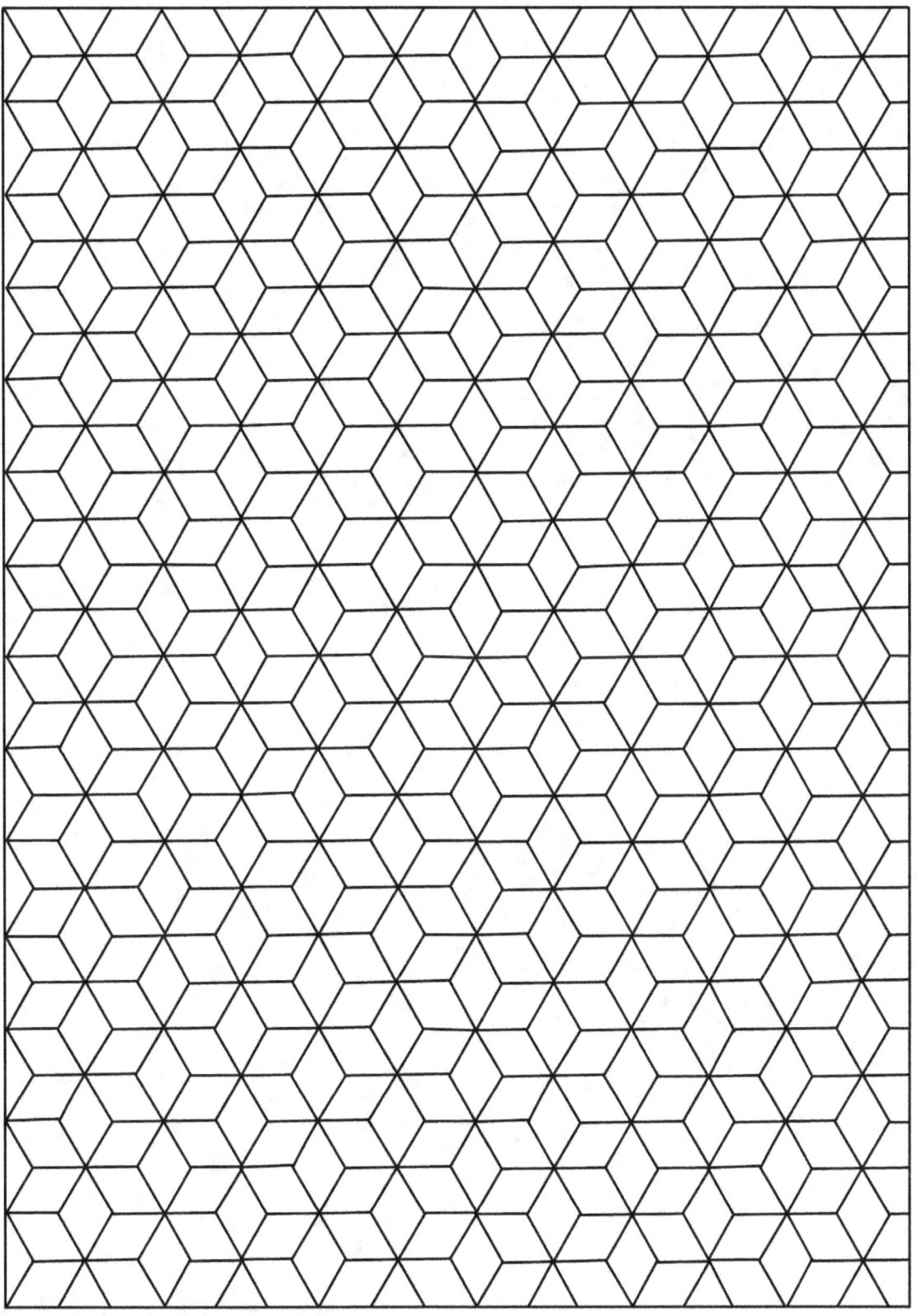

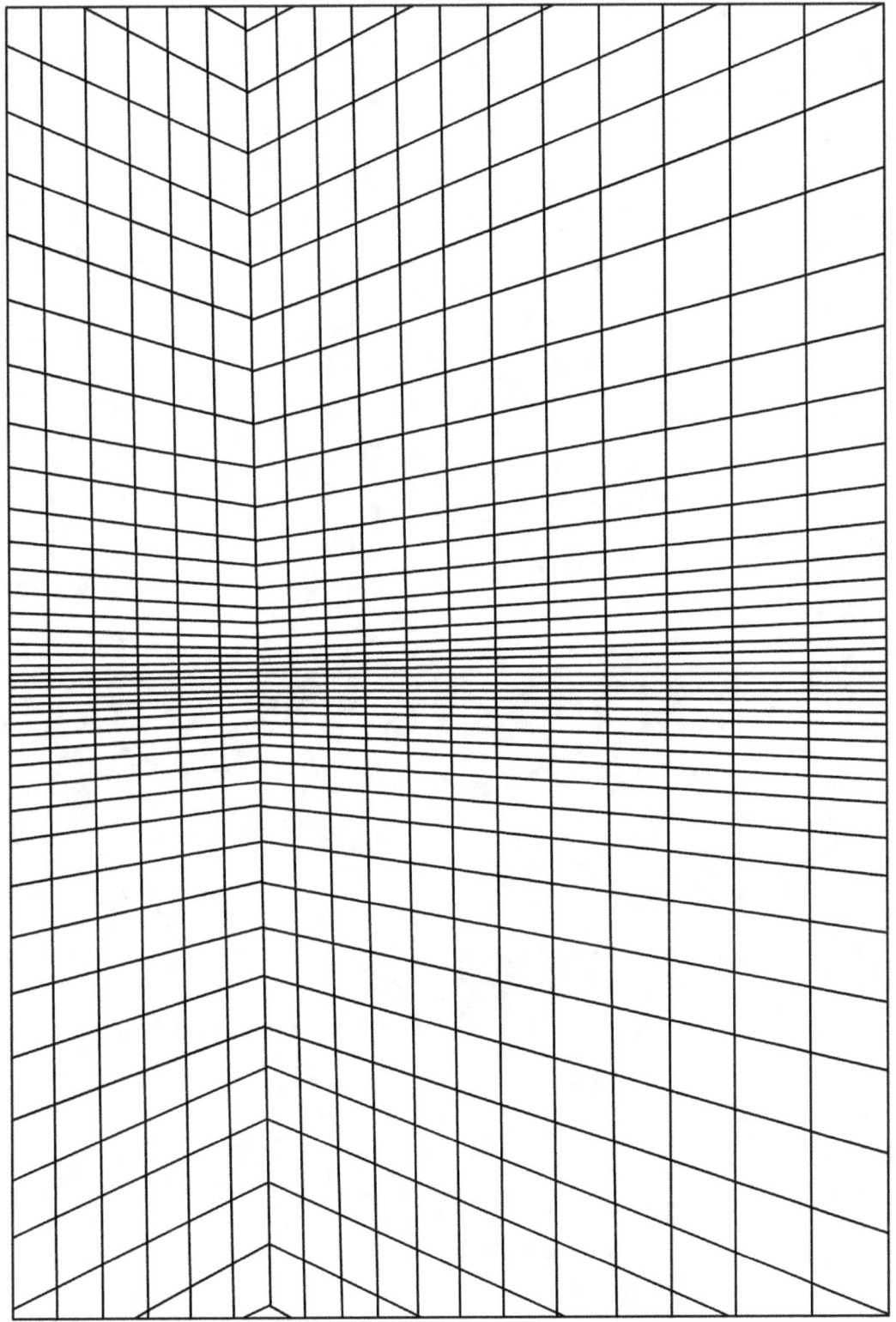

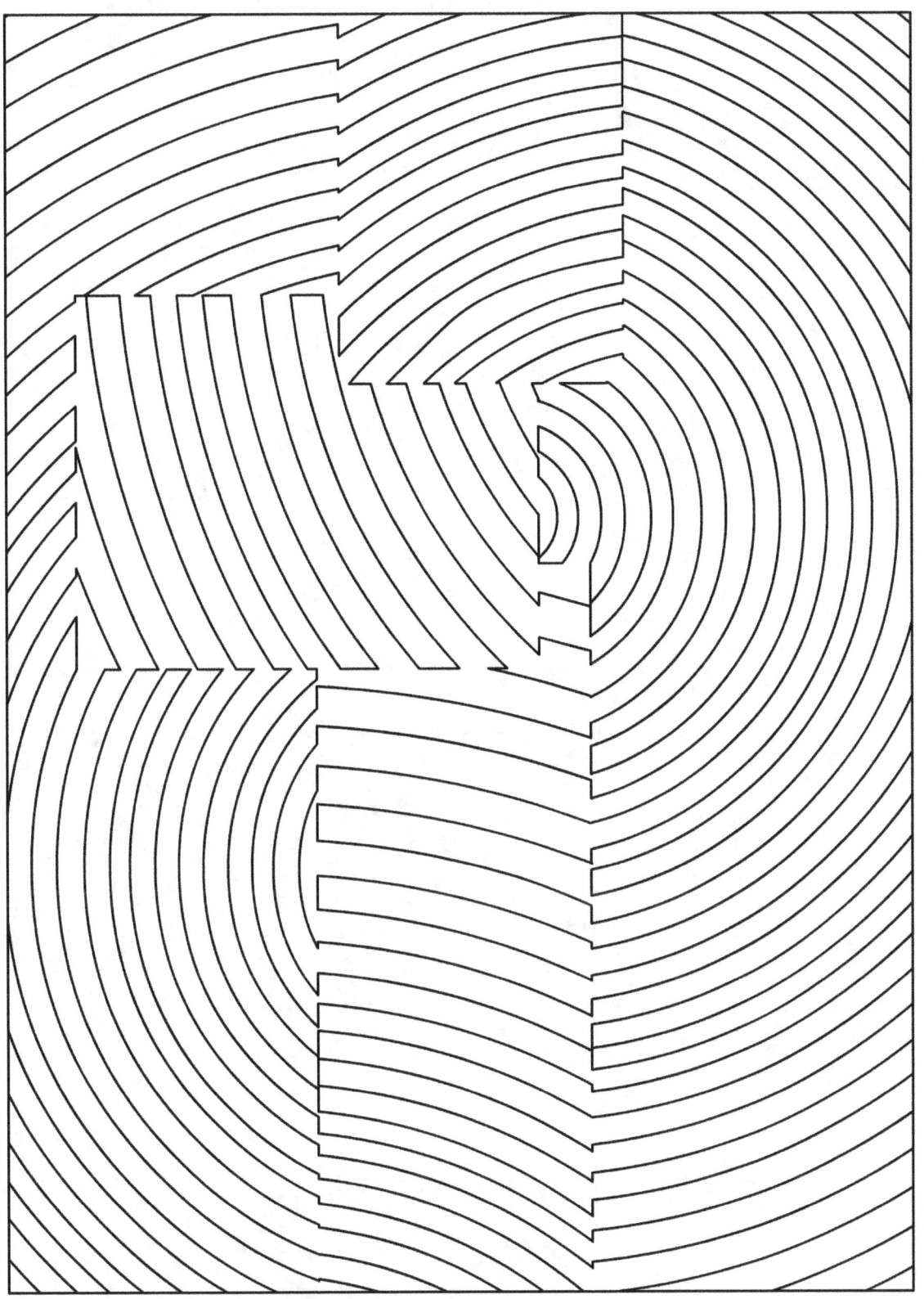

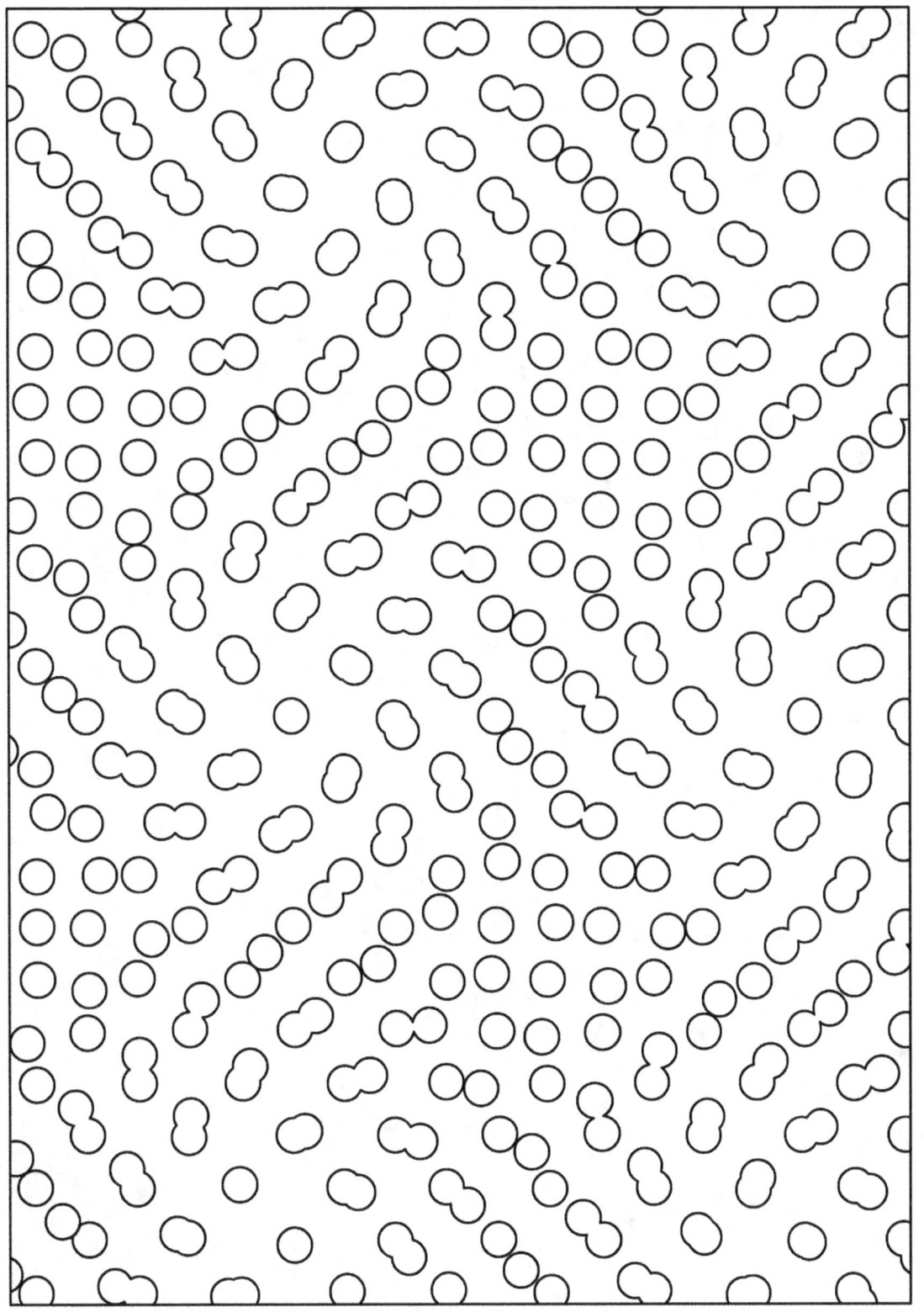

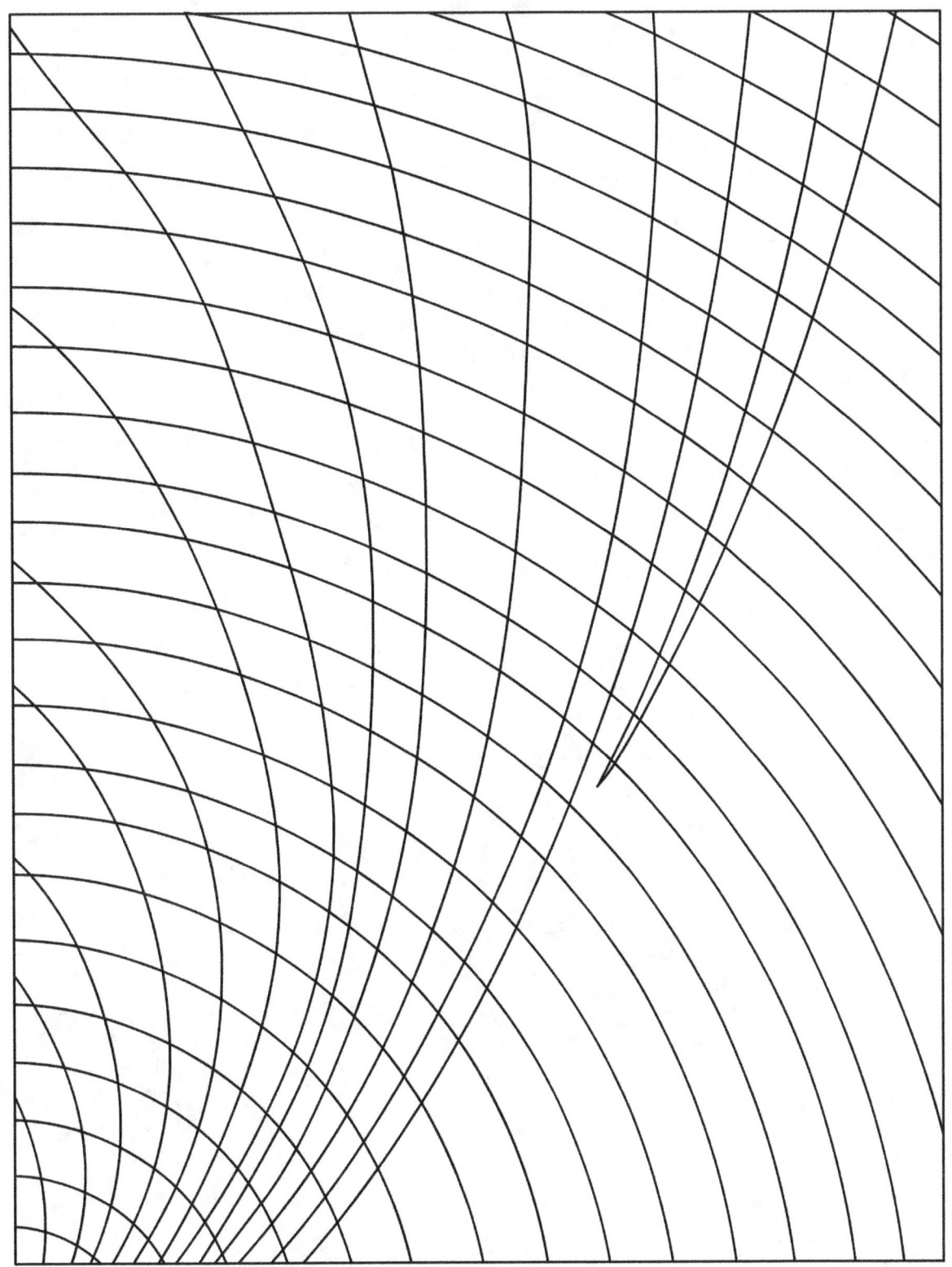

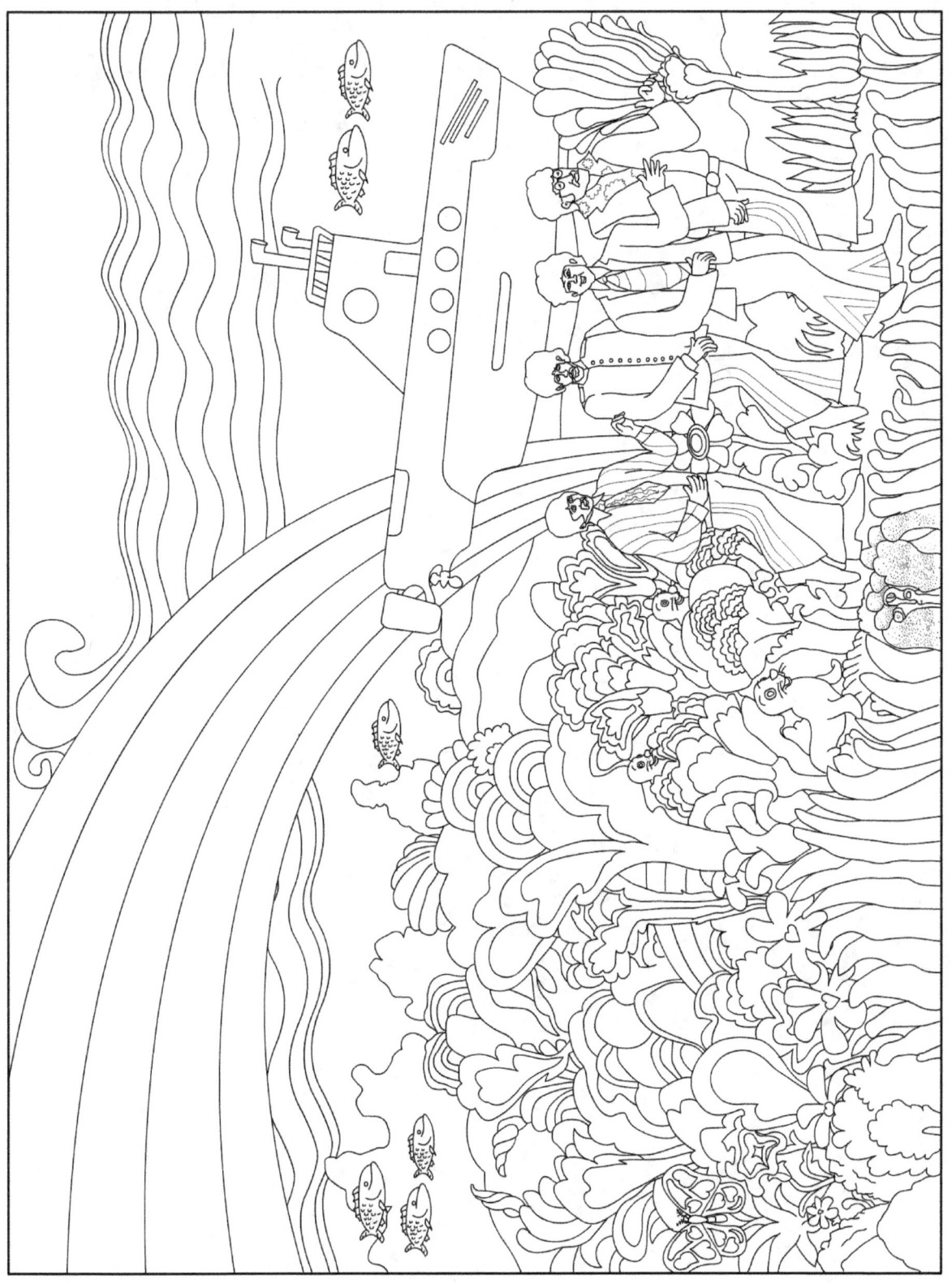

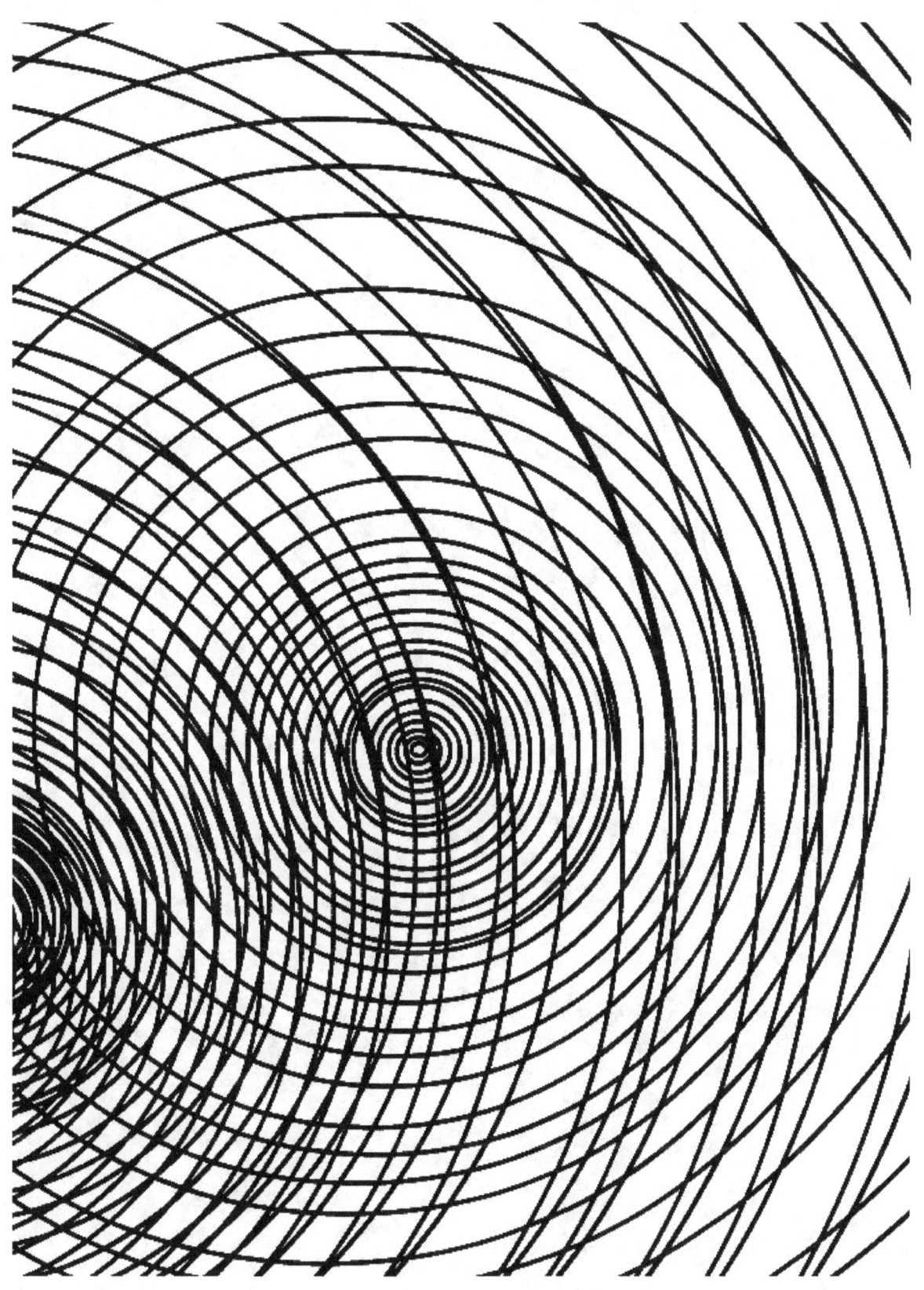

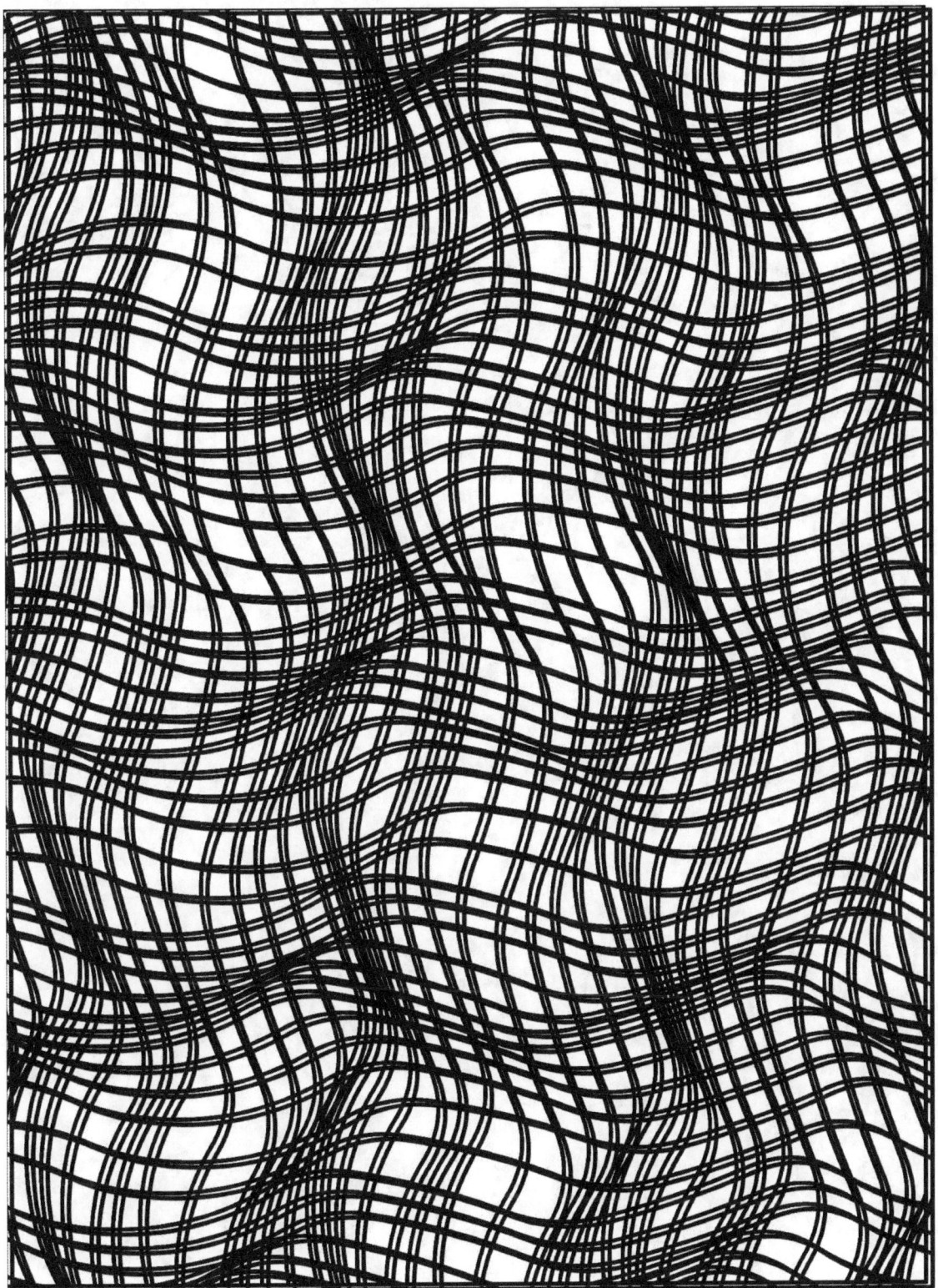

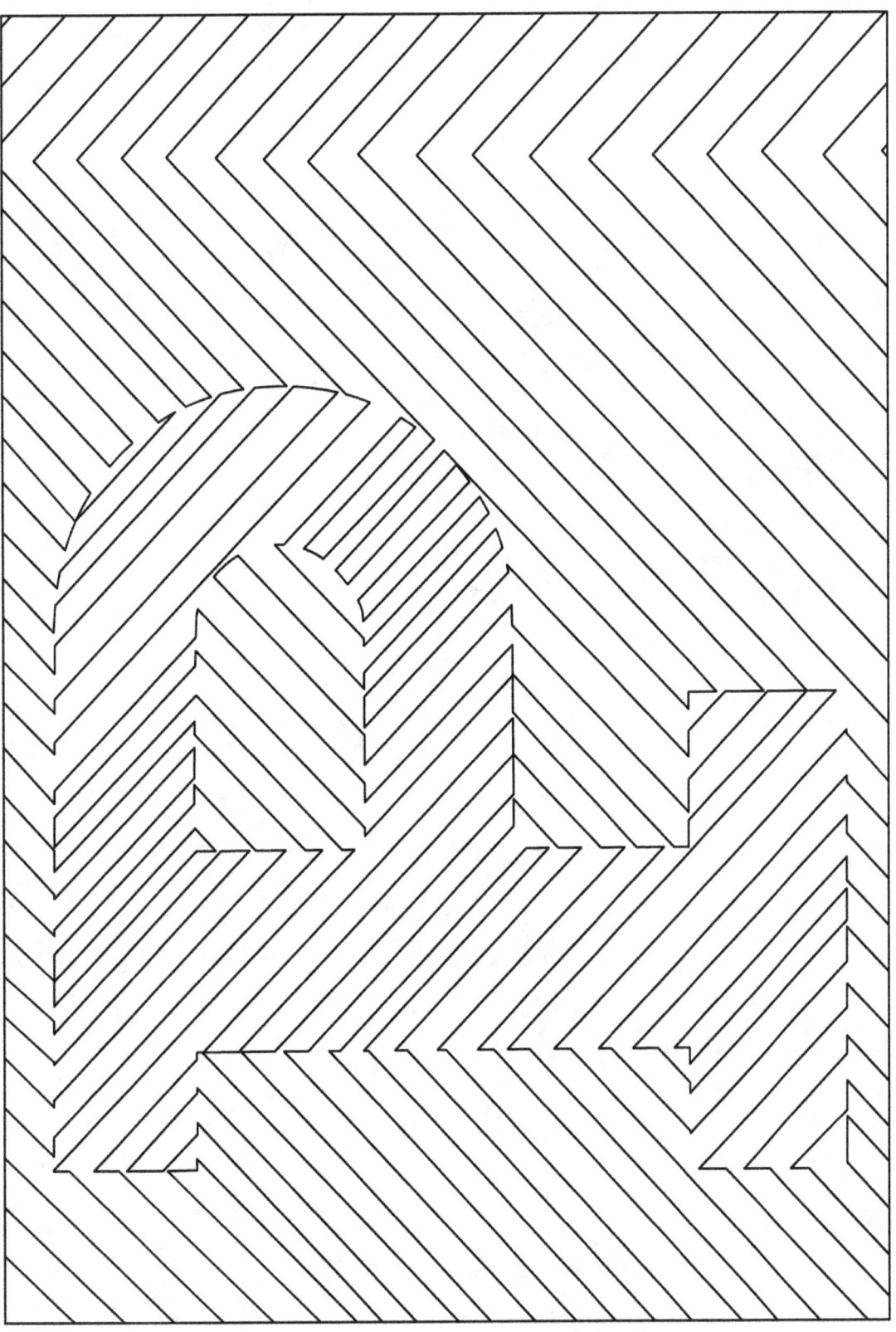

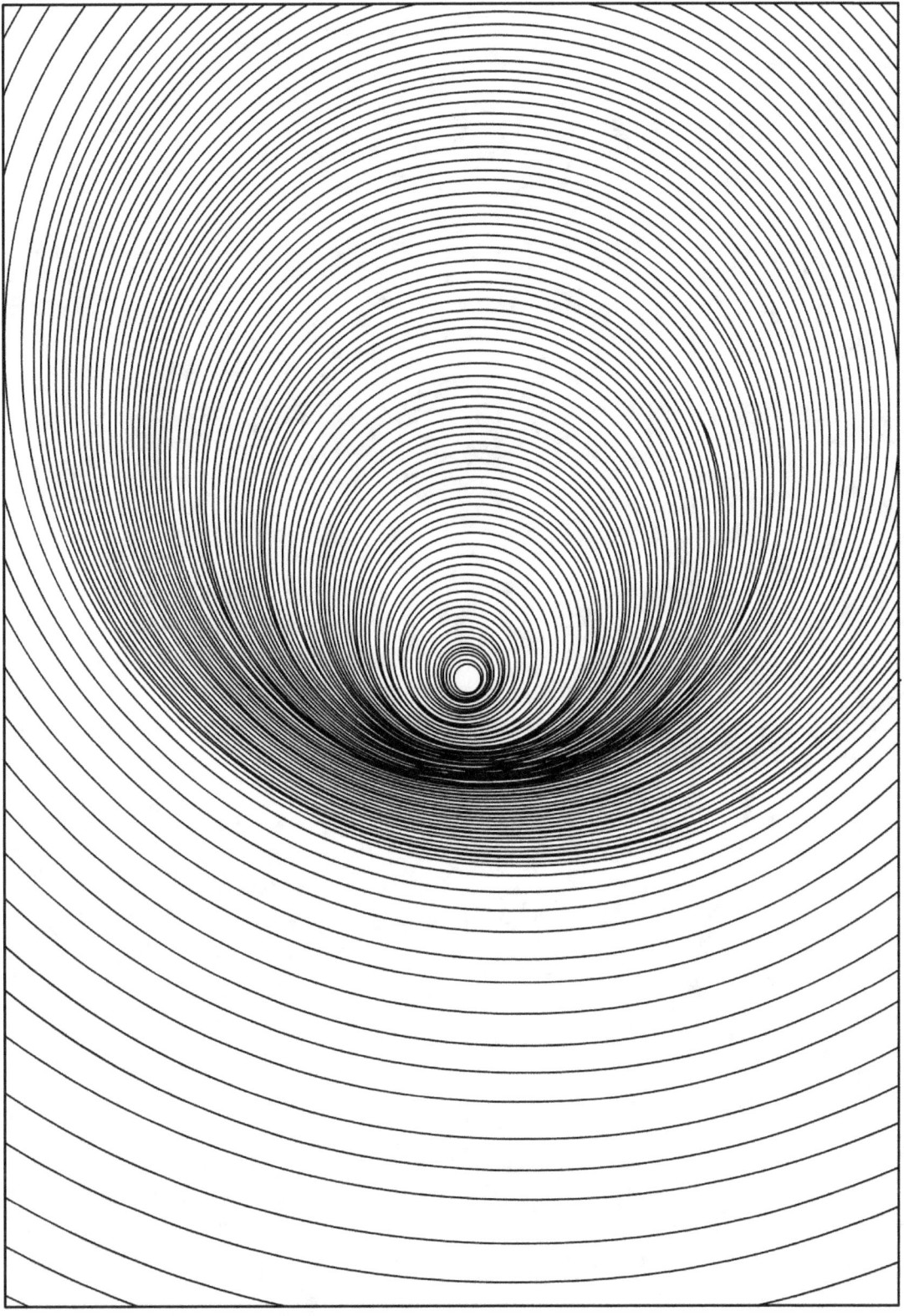

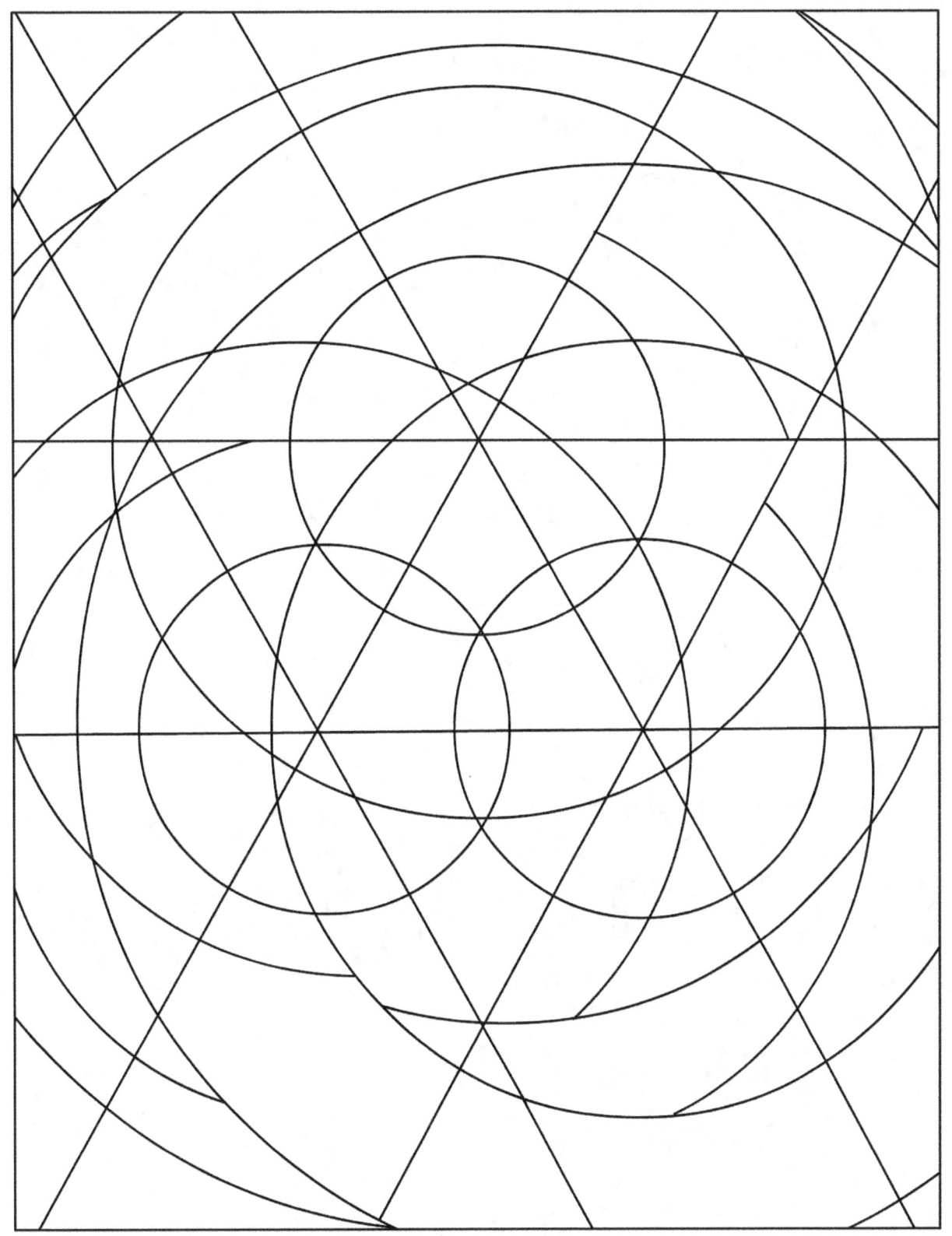

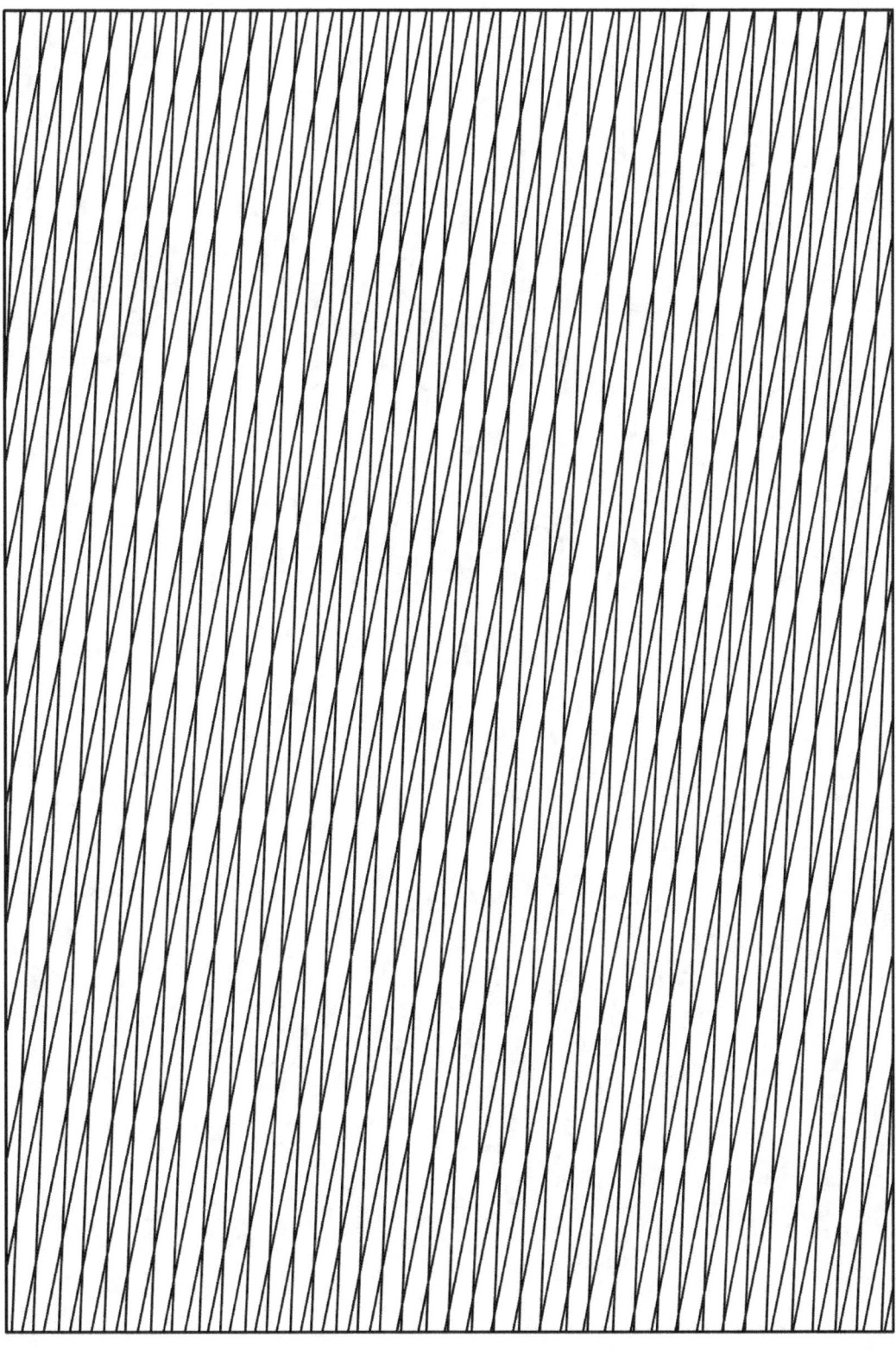

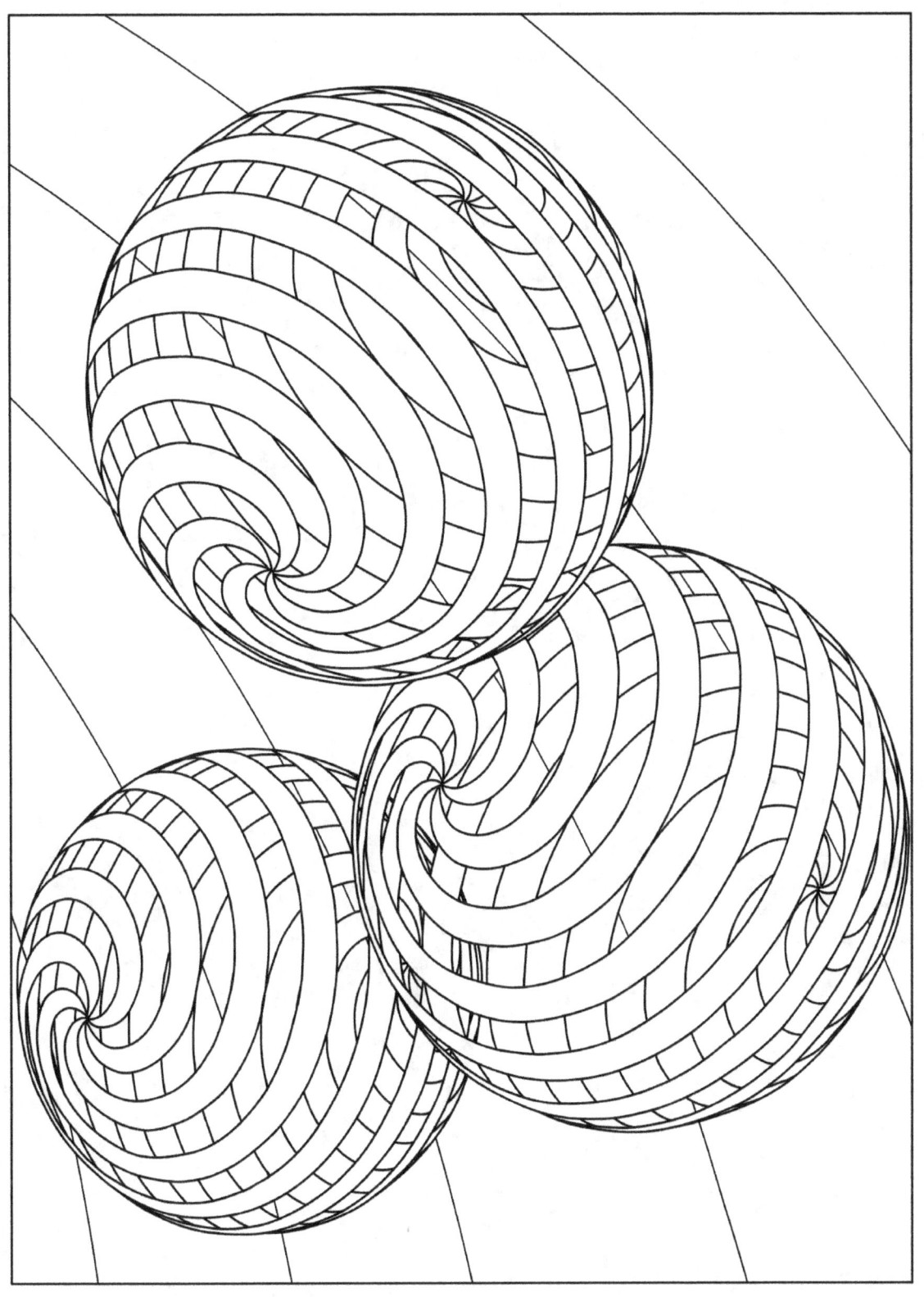

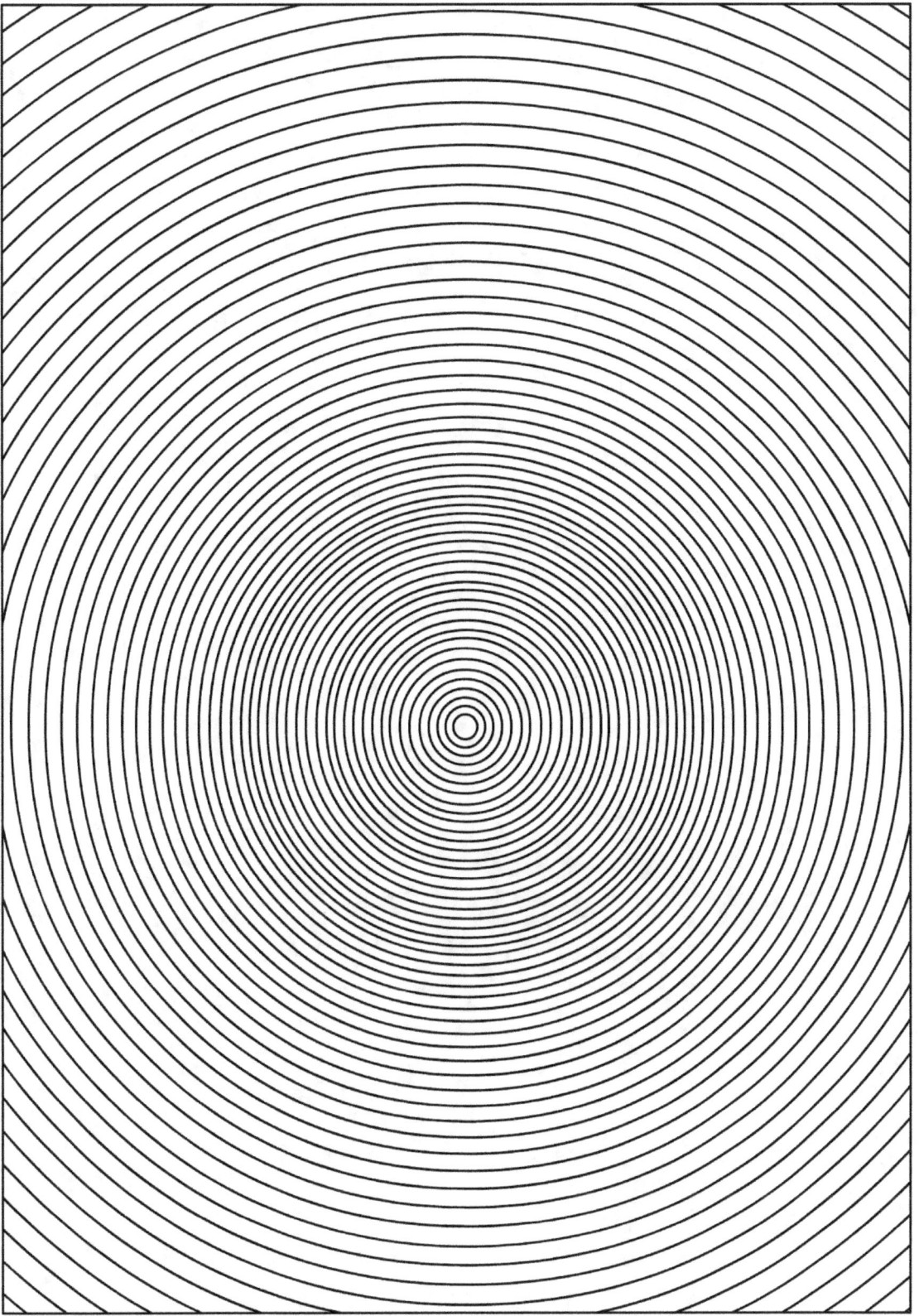

You can order large poster sized coloring pages of my designs from my website at Etsy.com Not only do I supply large sized images of the pages in this book, but images of Hawaiian scenes and even the Trump family from my other books. Make colorful posters for your room!

I have over a hundred large Hawaiian canvas prints and paintings, and nearly 200 smaller watercolor/prints at my Etsy art site. The coloring book pages of my Hawaiian Scene coloring books are based on some of these paintings.. If you like my Hawaiian art, check all of these out at hawaiiseascapes.etsy.com

Check out my other books at Amazon. I have these books currently published:

 Making of Psychedelic Brain Freeze: An Illustrated Book for Adults (explains the science behind optical illusions, shows how to color large poster sized pages to make your own art.)

 Relaxing Hawaiian Scenes, An Adult Coloring Book (first in the series)

 Relaxing Hawaiian Scenes II, An Adult Coloring Book (2nd in the series)

Portraits of President Donald Trump and the First Family: an Adult Coloring Book (attractive personal pictures of all of President Trump's family)

Making of Portraits of President Donald Trump and the First Family, An Illustrated Book (explains some of the hidden Easter egg images in the drawings)

 How to Import From China Starting With $250 and Make a Small Fortune!

Creation of the Universe and Other Strange Mormon Beliefs Revealed. (A church member tells all the Secrets the Authorities Don't Want to Talk About.)

How To Use Your Money Making Genes to Become a Success and Make a Small Fortune.

How to Publish Books on Amazon Kindle and Make a Small Fortune, The E-Book Money Making System

Thanks....

www.ingramcontent.com/pod-product-compliance
Lightning Source LLC
Chambersburg PA
CBHW081256180526
45170CB00007B/2452